SNEAKERS ART
From Inspiration to Customisation

Contents

6	Introduction		165	Tutorial 11
10	Materials, tools and techniques		168	Glitter mania
16	Brush & marker		175	Tutorial 12
21	Tutorial 1		178	I love
26	Street style		186	Art gallery
29	Tutorial 2		196	Children design
33	Tutorial 3		201	Tutorial 13
42	Pop - fluo - metal		206	Mix style
47	Tutorial 4		219	Tutorial 14
57	Tutorial 5		222	Studs & Co.
68	Camouflage & animalier		227	Tutorial 15
75	Tutorial 6		237	Tutorial 16
84	Denim project & Co.		240	Shadows & stains
95	Tutorial 7		262	Letter 22
98	Fire walk with me		268	Extraordinary women
106	Nightmare		272	Fur & feathers
123	Tutorial 8		286	Vintage
126	Save the earth		296	Simplicity
140	Flowers & fruits		304	A pen story
145	Tutorial 9		309	Tutorial 17
153	Tutorial 10		312	Black or white
156	Pins & patches		323	Tutorial 18

Intro-
duction

SNEAKERS: BIRTH OF AN ESSENTIAL ACCESSORY

The creation of the first sneakers is attributable to Native Americans. While walking trails and on hunting trips, they protected their feet with a layer of natural latex, an early prototype of the rubber sole.

The first rubber-soled shoe was made in 1850 in England, but it wasn't until the 1896 Athens Olympics that it became a mass phenomenon. But the event that sealed the sneaker's reputation was the 1936 Berlin Olympics, when the great Jesse Owens wore a pair of adidas and won no less than four gold medals, breaking all records.

In the 1950s James Dean wore a pair with jeans and a leather jacket, taking them from mere sports attire to a symbol of youth rebellion.

The transition from simple gym shoe to fashion statement occurred in the 1980s, when the athlete Michael Jordan endorsed the Nike Air Jordan in an advertising campaign, transforming them into the sneakers par excellence.

Next to endorse sneakers as an element of high fashion was Giorgio Armani, who paired them with classic suits and tuxedos, and wore them himself at his fashion shows.

Matthew Foulds - Unsplash

MOST POPULAR SNEAKERS

NIKE AIR JORDAN: appeared on the market in 1985 and immediately became a legend in basketball and street style. The various models sold like hotcakes, creating a true sneaker phenomenon that had a socio-cultural impact throughout the world. Produced in all kinds of styles and colours, both high-top and low-top, Nike Air Jordans are a true cult phenomenon, so much so that they are the sneakers most widely used for transformation and customization. Available in multicoloured leather, they are the object of desire for both young and old, of every gender. They can reach astronomical figures if signed by famed champions or decorated by prominent sneaker artists. The latter kind are often seen on the feet of influencers and personalities from the world of entertainment.

Apostolos Vamvouras - Unsplash

The Dk Photography - Unsplash

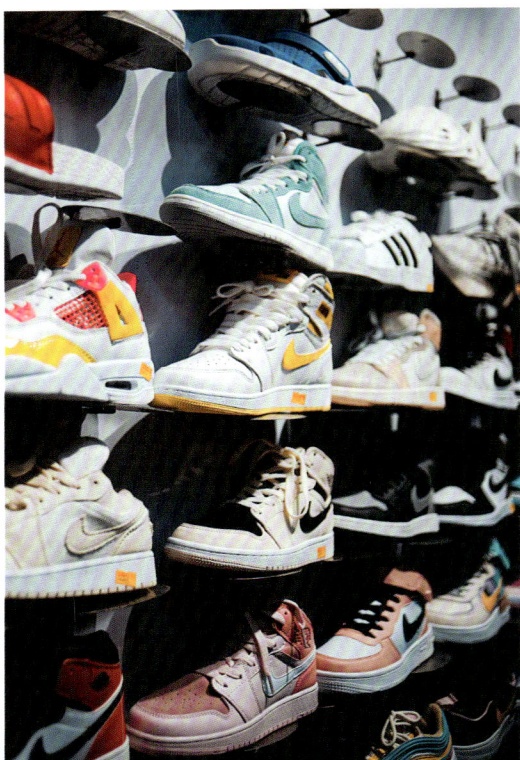

Deepal Tamang - Unsplash

made it a classic among students. This is also one of the best-selling sneakers ever.

ADIDAS SUPERSTAR: originally conceived in the 1970s as a basketball boot, in 1986 it became an icon of street style thanks to the American hip hop group Run DMC who recorded the single "My Adidas", dedicated to the Superstar.
Produced in hundreds of colours and countless variations, it is much loved by women today.

SNEAKERS AND HIGH FASHION

There are plenty of high-fashion brands that have included sneakers in their ready-to-wear lines: Balenciaga, Gucci, Fendi, Armani, Dolce & Gabbana, Yohji Yamamoto, Burberry, and Alexander McQueen are just some of the big brands offering this versatile accessory, thereby vastly increasing its sales and extending it to a wider audience of buyers of all ages and genders.
This transition enshrines sneakers as a true style icon, and not just a gym shoe. Worn in a context other than its original one (sport), sneakers have conquered the market, appealing to people of all ages and backgrounds, and becoming an accessory that can be stylish, refined, casual chic, preppy, grunge, dark punk, vintage, sporty glam, and street.
Every detail determines a different style. So why not create your own custom sneakers?

ADIDAS STAN SMITH: originating in the 1970s as a leather tennis shoe, it was worn by U.S. champion Stan Smith after whom it was named. Following a long hiatus, it made a comeback in 2014, and to date is the best-selling model ever.

CONVERSE ALL STAR: created in 1920 by the Converse Rubber Company as basketball shoes, they were worn by champion Chuck Taylor, head coach of the Converse All Star Team. Suitable for summer wear, today these canvas sneakers are also made in winter fabrics, such as leather, wool felt, and eco fur. It is not uncommon for this shoe to adorn the feet of brides determined to defy convention and add a touch of extravagance to their look.

PUMA SUEDE: born in 1968 as a running shoe, it evolved into a basketball shoe in the 1970s as the Puma Clyde, named after the famous athlete, Walt "Clyde" Frazier. The elegance given by its suede leather and soft colours quickly

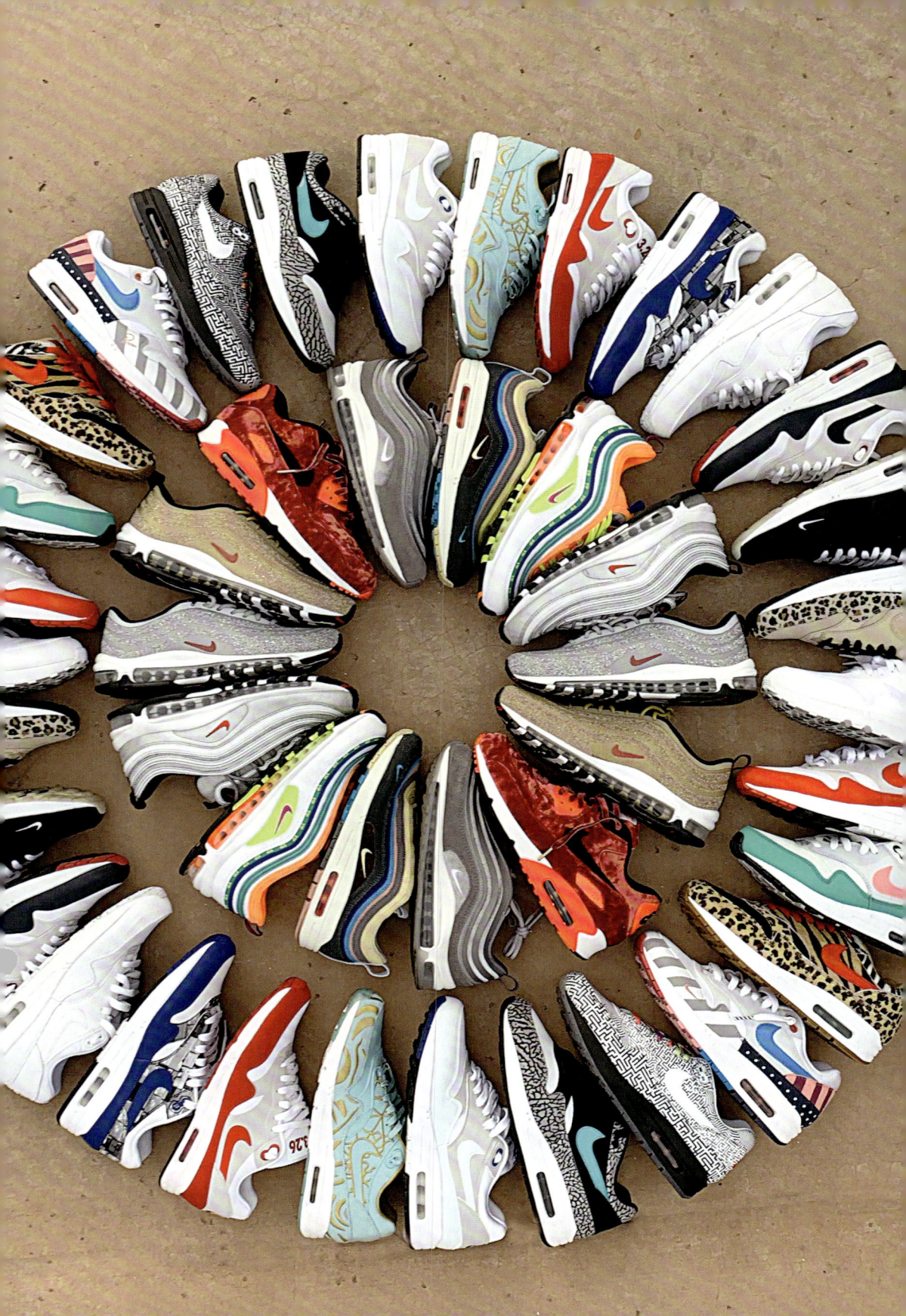

Materials, tools and techniques

10

Much imagination and creativity are definitely the indispensable elements for making your custom sneaker unique. But for every idea there are countless ways to realise it. Below we will look at the most effective tools, materials and techniques for making your own creations, but of course you can experiment with others yourself. The important rule to remember is that every shoe is different, so, to avoid damage, it is crucial to always test any product on small, hidden areas to see how they react with different materials. The tutorials suggest tools and materials that are readily available and can be purchased from local and online retailers. For each category there are many alternatives, so test brands and types, and decide for yourself which are best suited to your needs.

PAINT MARKERS

Acrylic paint markers are very easy to use, even for those who are not experts in painting techniques, and they come in numerous brands and colours, and with different types of tips (fine, medium, or broad). They are suitable for any type of material, whether leather or fabric.

When using them (and in general when working with any kind of material) always first remove the laces from the shoe to avoid staining them and make your work operations easier.

You can also use acrylic paint markers on surfaces that have a factory finish, but removing it with a primer (or ordinary nail polish acetone) will make the result longer lasting. Apply the primer with a cotton-wool ball and use a cotton bud to remove the finish, including all the harder-to-reach parts.

With a pencil, trace the design on the shoe or decide which sections to colour. There is no need to mask the unaffected parts because markers are very manageable and do not run.

Once the design is complete, shake the marker to mix the colour inside. If the marker is new, push the tip several times onto a sheet of paper until soaked in colour. Place the shoe horizontally and colour the larger sections using a broad tip marker. Use a marker with a finer tip for the finishing touches (borders and other smaller designs). You can use a spray fixer to protect the design when finished.

FABRIC MARKERS

These products are especially suitable for colouring canvas sneakers because the pigment penetrates the fabric weave and is water-resistant, so washing or rain will not be a problem.

Again, there are markers with tips of various widths and types (regular or brush). Use those that best suit the type of design you want to create.

Trace the basic design with a soft 2B pencil, as a pencil that is too hard may not show. Fabric markers closely resemble paint markers, so follow the instructions above when using them.

INDELIBLE MARKER PENS

These markers can also be used on shiny surfaces, such as plastic or metal, and black ones, which have the best coverage, are employed most often, to the detriment of other colours. If used to draw on white material they can give an excellent result, being also very simple to use.

These markers do not require a primer to be applied first because they can be used on any surface. You can use them on both leather/eco-leather and canvas, and various fabrics, and they are suitable for making single line tattoo-type designs or for lettering.

You can also use them to outline paint-coloured designs, giving a highly distinctive effect.

ACRYLIC PAINTS

The most commonly used type of colouring for sneakers. There are specific ones for shoes, and many of the better-known professional brands also manufacture a number of accessory products: a primer, useful for preparing leather shoes by removing the factory finish that makes them waterproof and so unreceptive to colour; a thinner, used to dilute the paint and make it more or less liquid depending on its use and the desired effect; and a finisher, which renders the shoe waterproof and thus protects the colour design. Usually this type of paint is already highly durable, so the finisher is mainly used to achieve a matte or glossy end result. In addition, manufacturers also often recommend the types of brushes to use with the paints, including airbrushes.

Before using them, as always remove the shoelaces, then apply tape to mask the areas you don't want to colour.

Mix the paints to obtain the desired colour, using white or black to lighten or darken the shade.

Add the thinner to dilute the colour (usually 50% paint and 50% thinner are used) and mix everything well.

With a medium-broad, flat, stiff brush, begin colouring the larger surfaces. Always wait until the paint is dry before moving on to the next colour; you can use a hair dryer to speed up the process. Paint the subsequent areas with different colours, always diluted with thinner. You can use a thin, hard-tipped brush or paint markers to create fine line drawings and to finish off details.

A toothpick can be useful for colouring the seams; dip the tip into the paint and run it over the seam line. Finally, apply the matte or glossy finisher.

If you want to achieve a spongy effect, instead of brushes use paint pads, which are sponges on a stick, very easy to use, and can be found in a range of sizes in paint shops. Alternatively, you can make them yourself by cutting natural sponges to the required size.

WATER-BASED ACRYLIC PAINTS

These paints give a good yield and are easy to use because they are diluted with water.

They are used in the same way as classic acrylics, but without a thinner, since they are diluted just with water.

However, a finisher must be applied to prevent rain or washing from fading the colour.

GLITTER

There are acrylic paints that are already glittered, but if you want to get a really bright result use glitter powder, available in a vast array of colours and shapes.

Use vinyl glue and apply it evenly with a brush until perfectly smooth. Use hot glue if you want to create reliefs.

Place the shoe on a flat surface with the part to be covered with glitter in a horizontal position (so the glitter won't fall off), shake the glitter over the glue and gently press it down with your fingers to make it stick. Wait until it is all thoroughly dry, then turn the shoe upside down to remove excess glitter.

There is also self-adhesive glitter paper available in a variety of colours. You can cut it out and glue it to the shoe, all you need to do is to first make a kind of "paper pattern": stick masking tape over the part of the shoe you want to cover, then remove it and place it over the self-adhesive glitter paper, cut out the shape and glue it to the shoe. The result will be flatter than powder glitter, but it will still look shiny.

You can also find glitter glues, but they contain very little glitter so the final effect is not as striking.

APPLICATION OF FABRICS

This technique involves the application of various types of fabric, such as denim, tweed, matelassé fabrics, wool felt, or any kind of cloth you might want to use.

In addition, you will need a few other commonly found tools and materials, like scissors, masking tape, and shoe putty or fabric glue.

Create the pattern with masking tape, as when covering the areas you don't want to colour. Once shaped, remove it from the shoe and apply it to the fabric. Neatly cut around the edges. At this point you can also create embroidered patterns with beads and sequins, exposed stitching, or even with the addition of stitched embossed elements.

Apply putty or glue with a brush to both the shoe and the fabric (never use a liquid glue otherwise you could stain the fabric) and spread it right to the edges. Wait a few minutes for the glue to solidify a little (follow the manufacturer's instructions) and apply the fabric to the shoe.

If you want to cover the whole shoe, proceed in the same way for all the other areas.

APPLICATION OF STUDS AND EYELETS

This technique is among the most popular, putting a youthful slant on custom sneakers without using paint.

For both leather and fabric sneakers, you will need a pair of punch pliers which, along with studs, can be bought from suppliers of shoemaking tools or online. Studs come in all shapes, raised, flat, cone, pyramid, and round.

With a pencil mark the spots where you want to apply the studs. The pliers have assorted punches of various sizes to make different holes; select the one that fits the stud to be inserted. Pierce the leather or cloth in the marked points.

Studs consist of two parts; insert the back from the inside and push it out through the hole. If the stud has a screw back, twist the outer part onto the inner one: if it is snap on, press until the two parts fit together. You can also apply different types of studs to the same shoe, just pay attention to the size of the hole for each one.

For making eyelets, as well as punch pliers, you will need a pair of eyelet pliers.

Eyelets are formed by a single element which resembles an open cylinder. After piercing the shoe, put the cylinder on the inside and push it out. Insert the punch of the eyelet pliers into the cylinder and press firmly. The cylinder will bend to form a ring and a hole with a metal surround will appear.

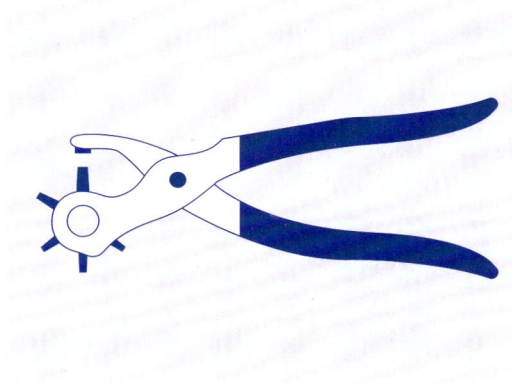

HYDRO-DIPPING

With this technique you can give your sneakers some really special effects. The tools and materials you will need are as follows: a large container (for example, a laundry basin), different-coloured cans of spray paint, masking tape, and a pair of latex gloves.If the shoe is made of leather, treat it with a primer and let it dry before starting.

Use masking tape to cover the sole of the shoe, both along the sides and underneath, and the parts you don't want to stain. Use a utility knife for a precise result. Fill the inside of the shoe with plastic bags (or similar) to stop any colour leakage.

Fill the container with water to twice the height of the shoe. Spray the water with paint, one colour at a time, to form concentric circles. Run a stick through the colours to create a wavy effect. Put on a pair of latex gloves and, holding the shoe by its sole, immerse the upper part.

Do not leave the shoe in the water, but immerse and remove it immediately, without moving it around in the water. The paint will adhere to the shoe, creating random streaks. You'll be surprised by the result.

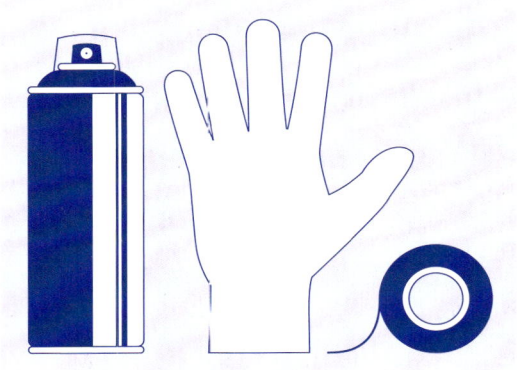

USING STENCILS

Creating designs with stencils is very easy and you can find them in all kinds of styles and lettering, but you can also create them yourself with tracing paper or masking tape. Stick masking tape onto a glossy surface (like glass) and create a solid rectangle with it. Draw the design or lettering you want on a sheet of paper and attach it over the masking tape rectangle with pins or scotch tape. With a scalpel knife cut along the inner edges of the design to create the desired shape. This technique makes the stencil adhesive and therefore very easy to apply onto sneakers.

If you are using tracing paper, create the design and apply it to the tracing paper with pins. Proceed in the same way as for masking tape and cut out the inner part. Stick the tracing

sheet onto the sneaker using masking tape on the corners and then proceed with colouring.

Dyeing is very easy as you do not have to follow the edges. With a brush or marker randomly apply the paint over the stencil. It is very important to wait for the colour to dry before removing the stencil so as to avoid smudges.

A variation of this technique involves using a piece of perforated fabric, such as a lace or dense mesh, instead of a stencil, leaving an imprint of the weave of the fabric. In this case you can also use spray paint, ensuring you cover the parts not to be coloured with masking tape.

Sanju Pandita - Unsplash

Brush & marker

16

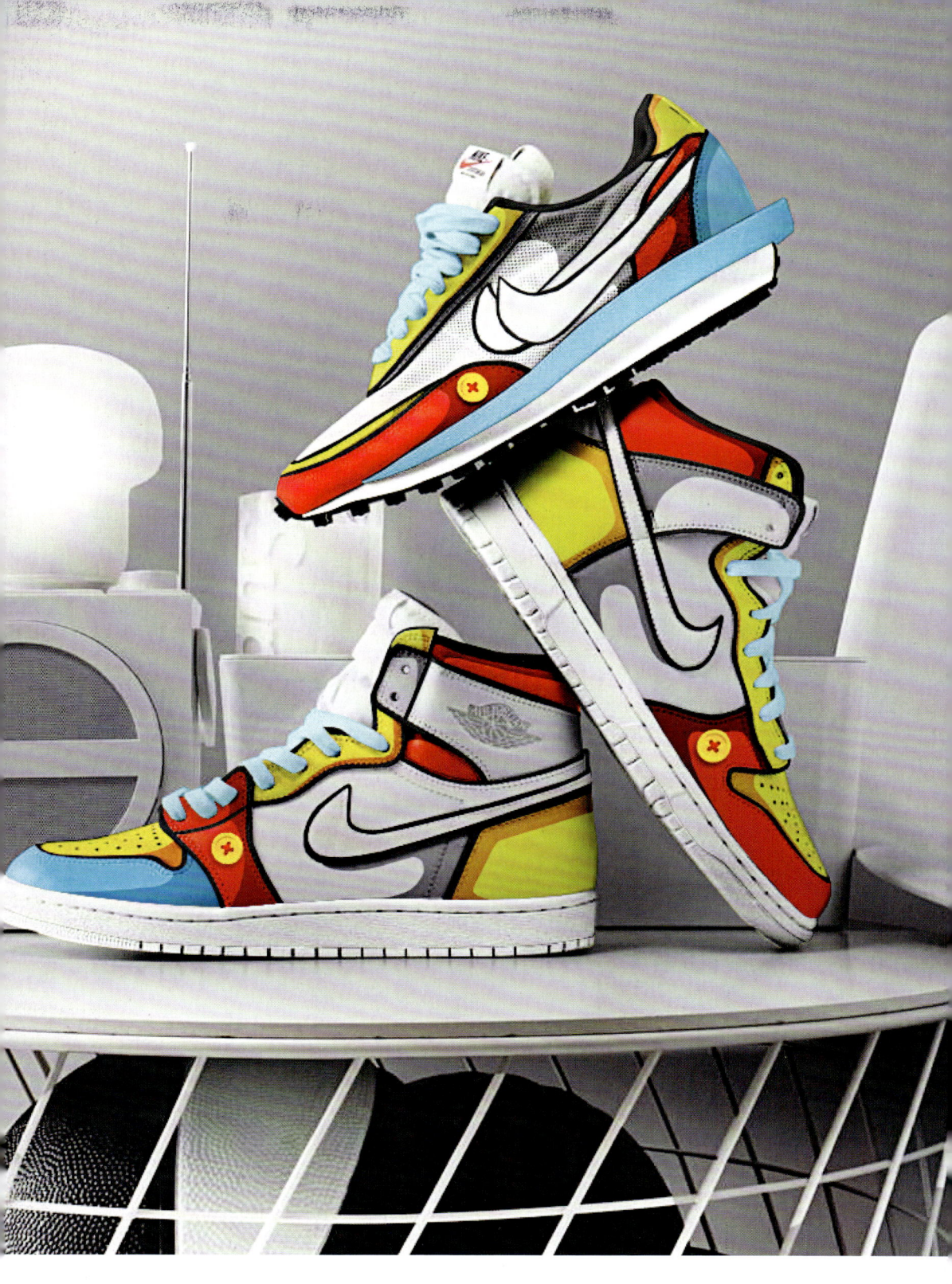

Stewie Stack, John Trottier, Johnnyskicks (@johnnyskicks_)

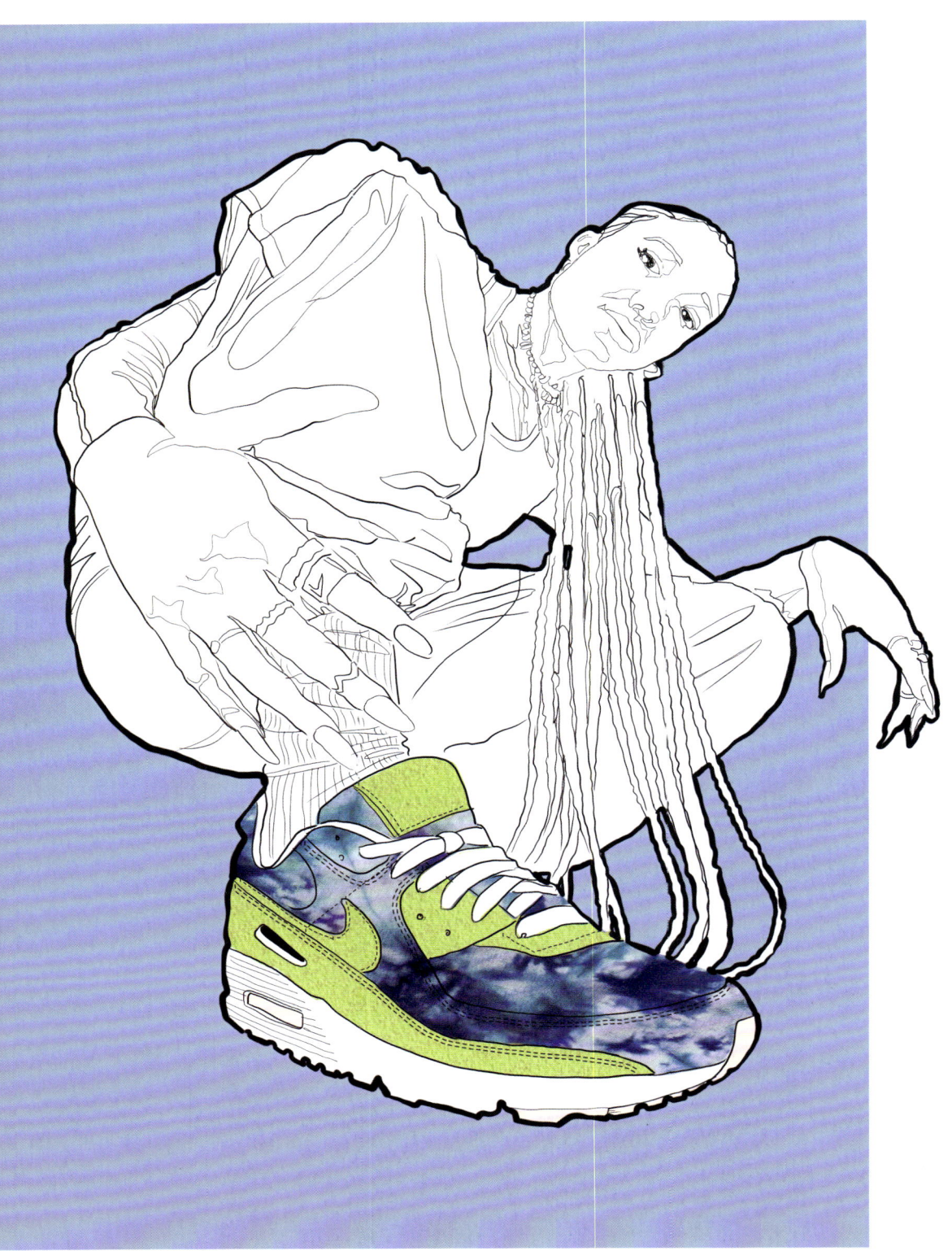

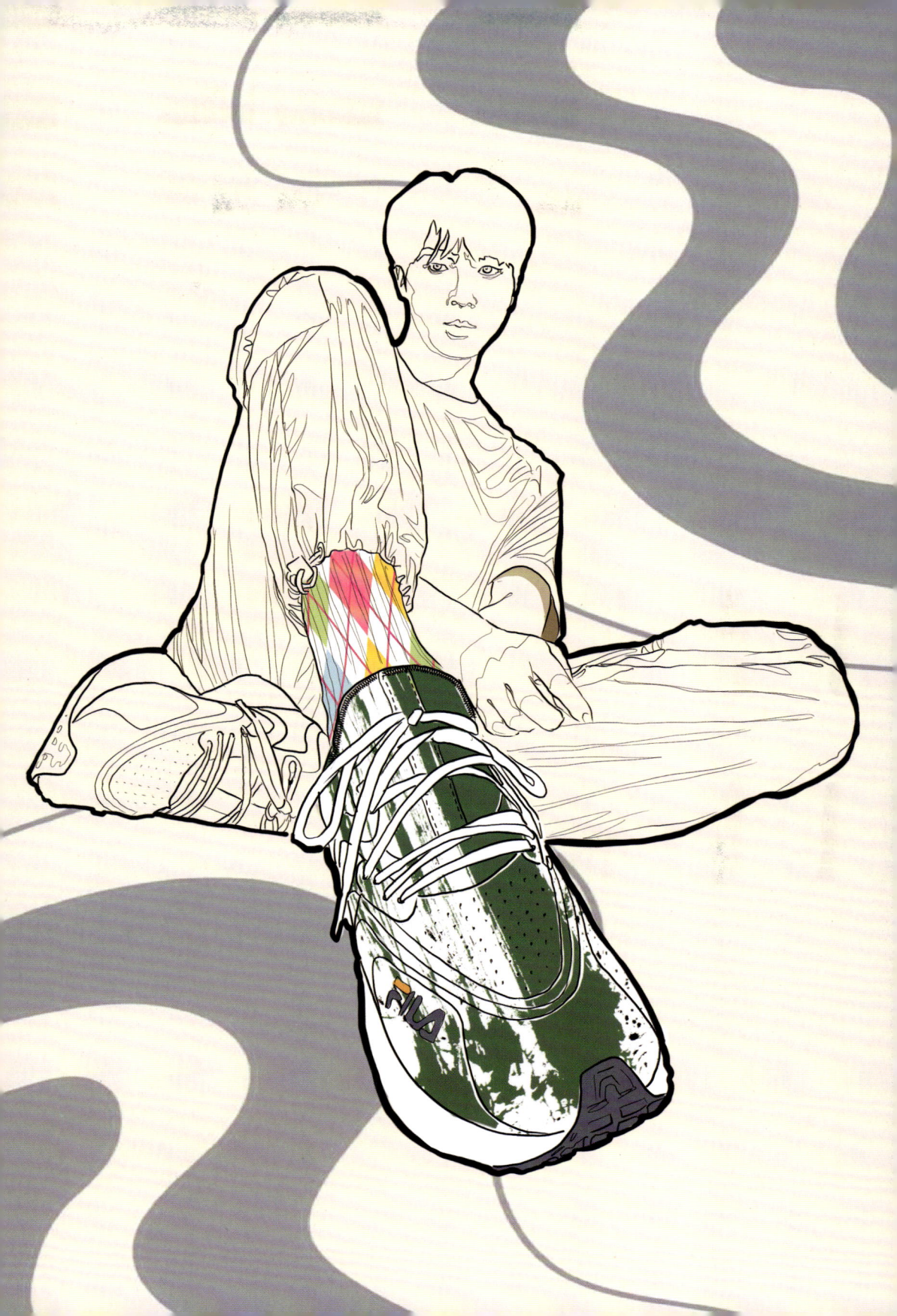

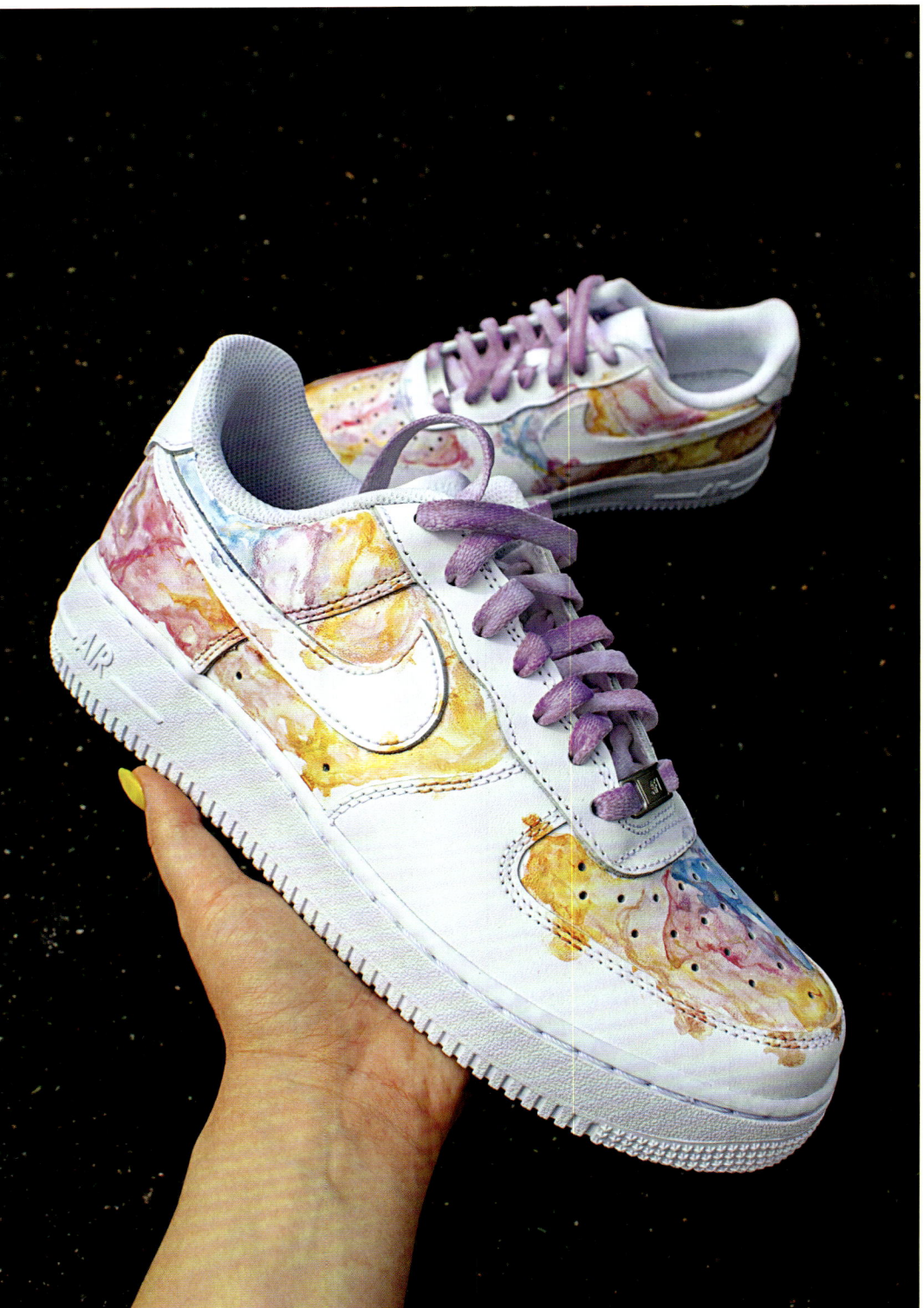

Watercolor Effect, Damikela Gjergji (@dami_customs)

Tutorial 1

Use a primer to prepare the leather for painting. Apply it with a cotton pad and allow to dry before proceeding.

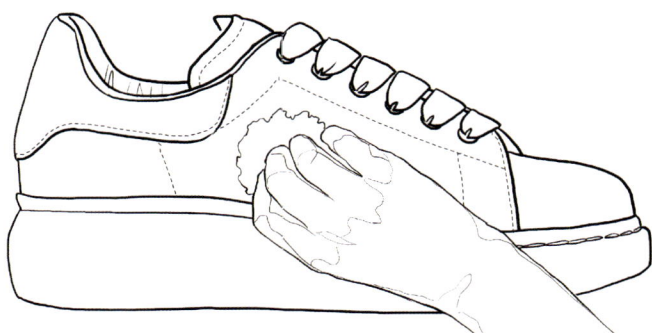

Dab the shoe with a sponge impregnated with paint. Stick masking tape over the areas you do not wish to colour.

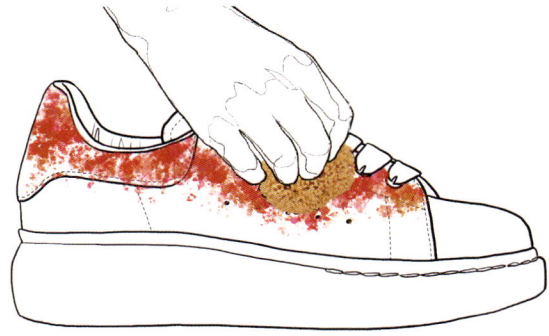

Acrylic paints for leather shoes.

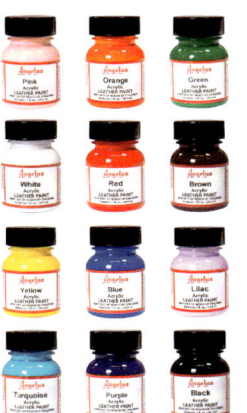

Dab the sponge over the spots where you want the colour to run.

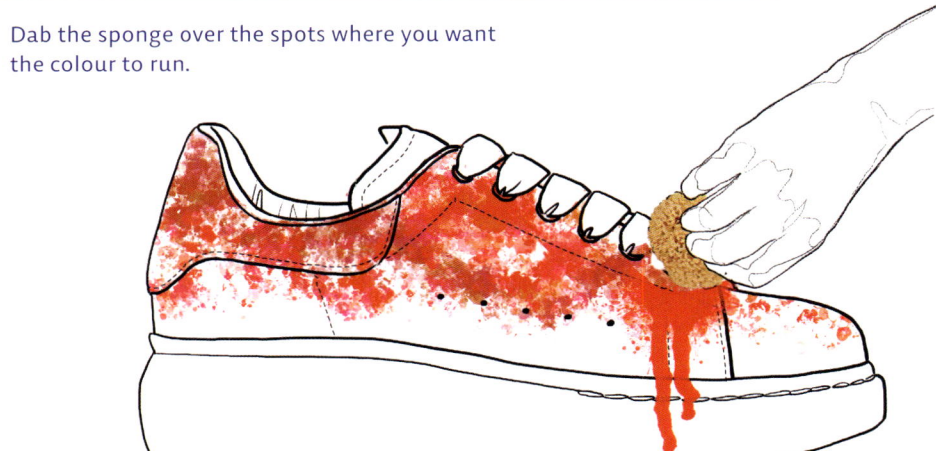

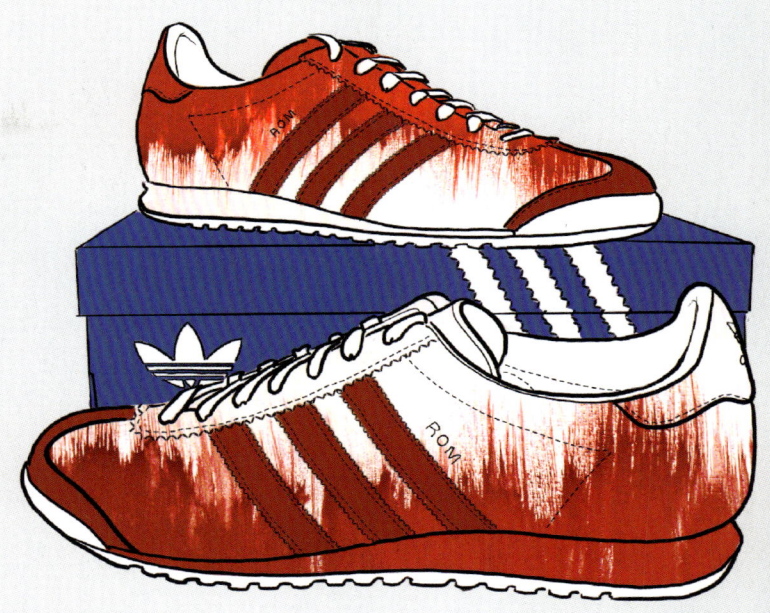

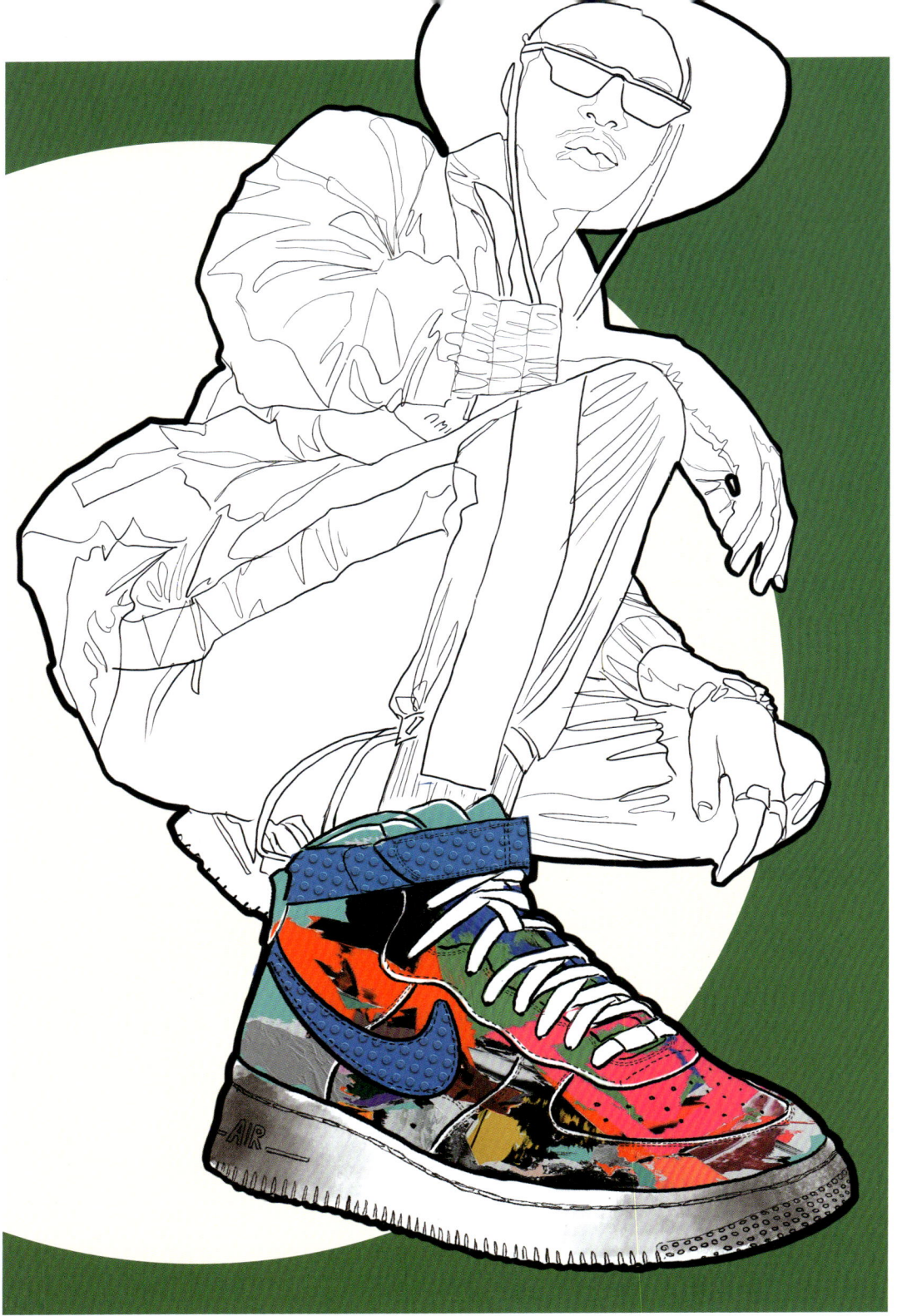

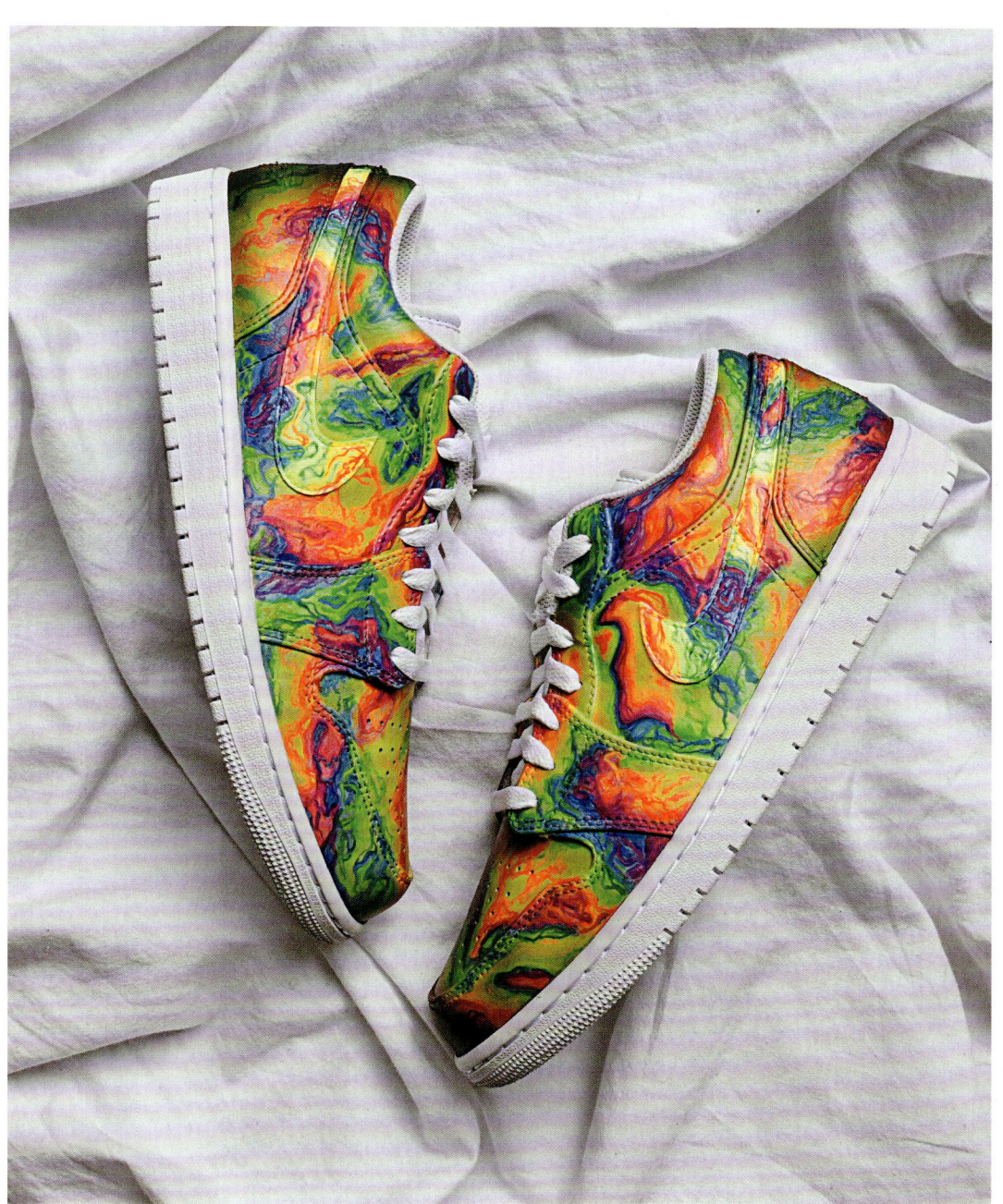

Oil Spill Jordans, Damikela Gjergji (@dami_customs)

Street style

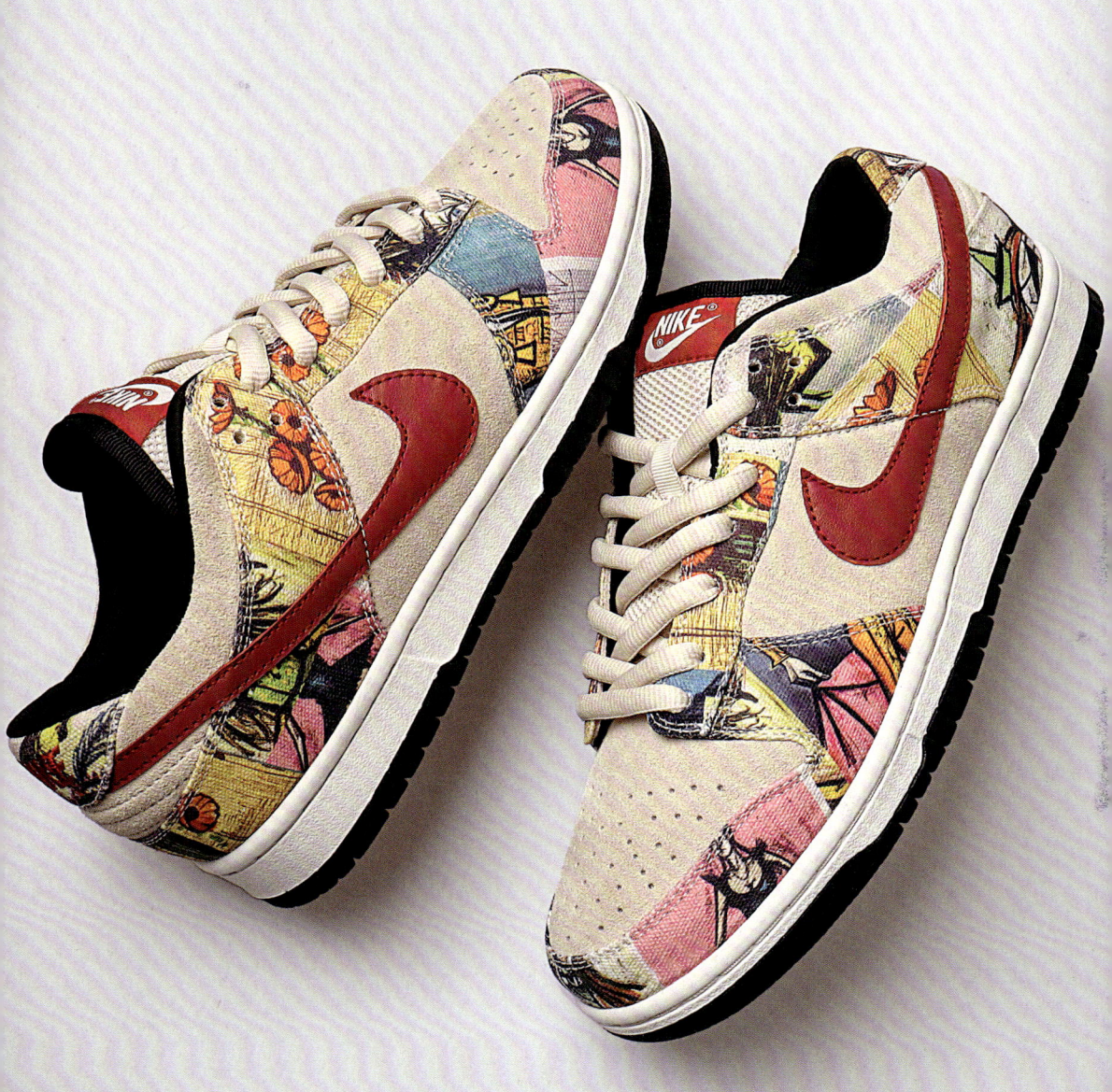

Paris SB Dunk reimagined customs, John Trottier, Johnnyskicks (@johnnyskicks_)

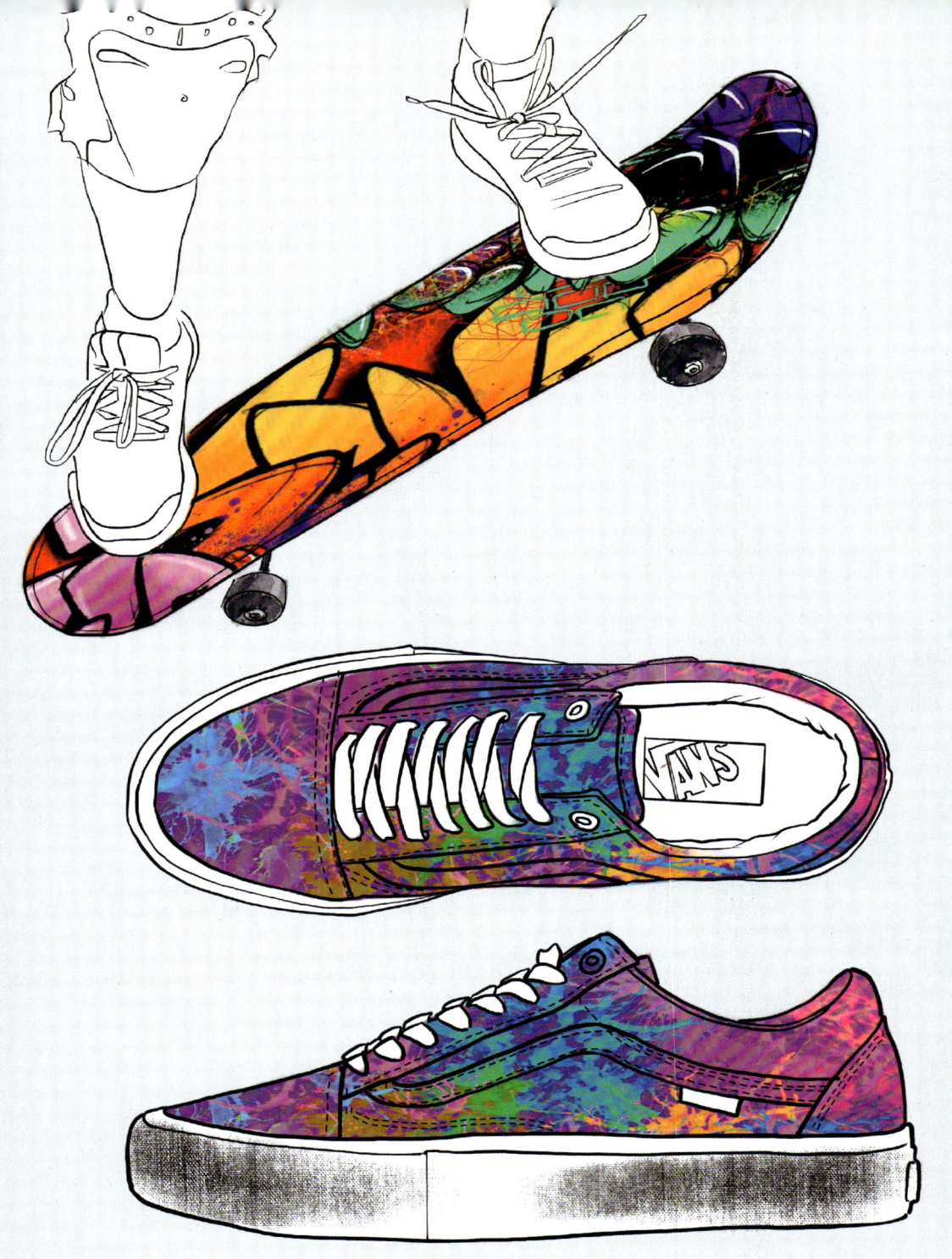

Tutorial 2

After treating the leather parts with a primer, make a street art style drawing with a thin technical pen.

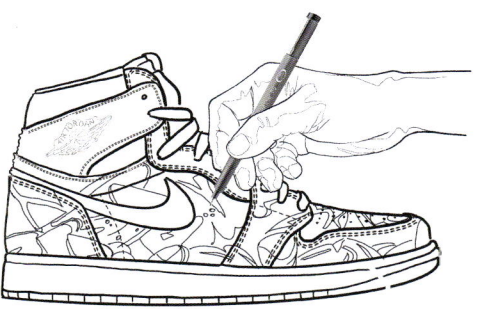

Colour the base of the design with acrylic paint markers, available in a huge range of colours.

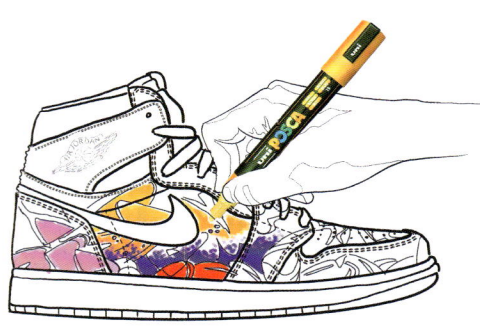

Go over the edges of the drawing with a black permanent marker.

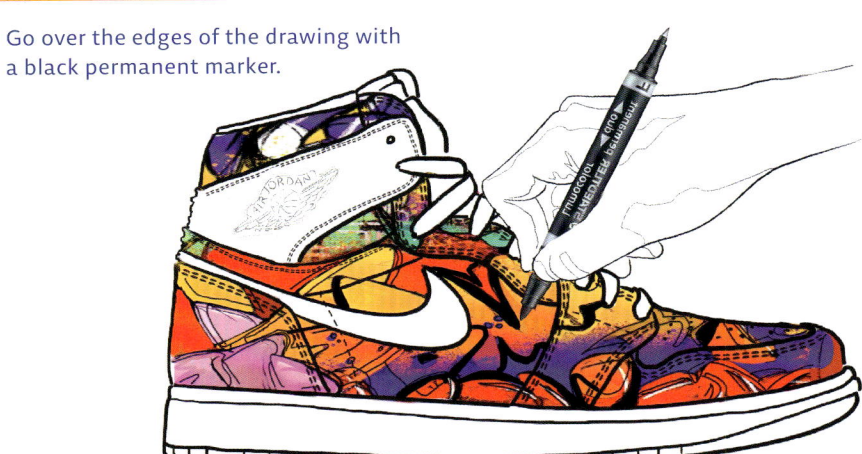

Colour the remaining parts of the shoe with a gold acrylic paint marker.

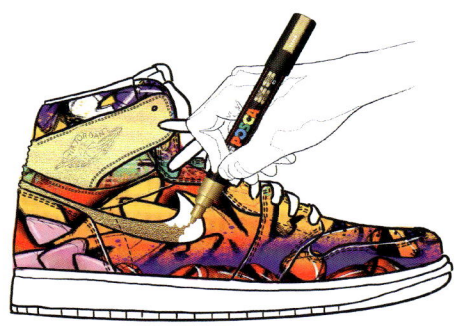

Red

Violet

Yellow

Fluorescent pink

Apple green

Orange

UNIPOSCA

Gold

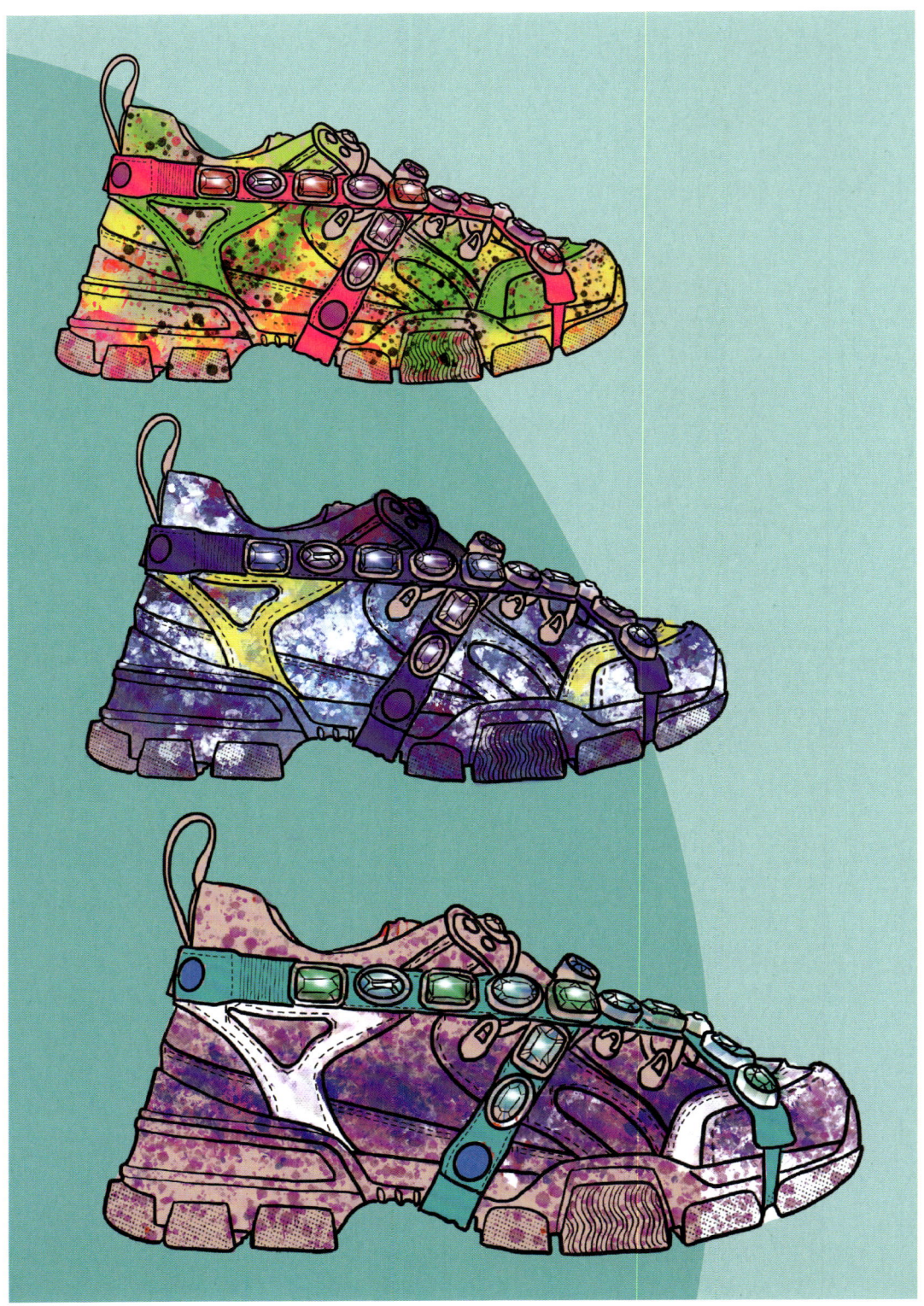

Tutorial 3

Acrylic colours, hard flat brush (or a hard toothbrush), small brush.

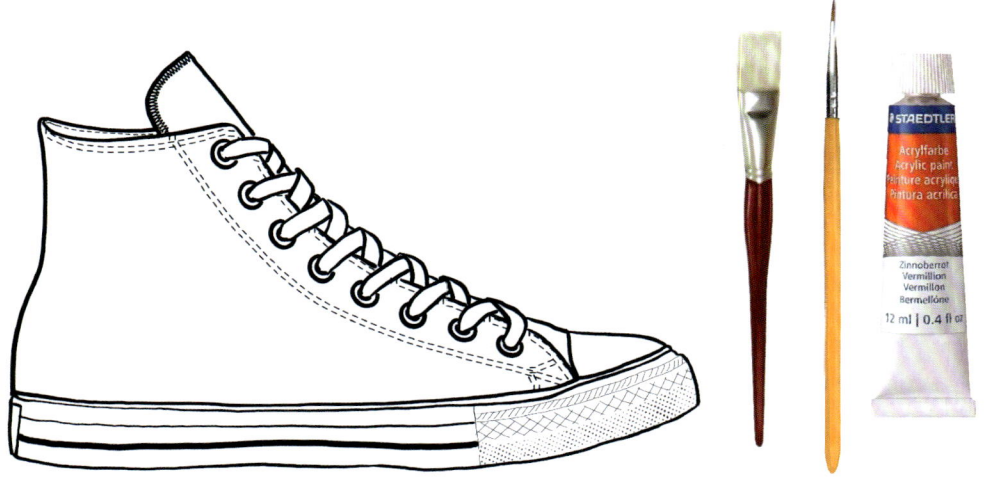

Dip the brush in the paint, then with your fingers flex the bristles and flick them over the shoe, splashing it with colour. Proceed by alternating different colours. With a small brush create random lines to join up the drips. The final effect will be similar to that of a Jackson Pollock painting.

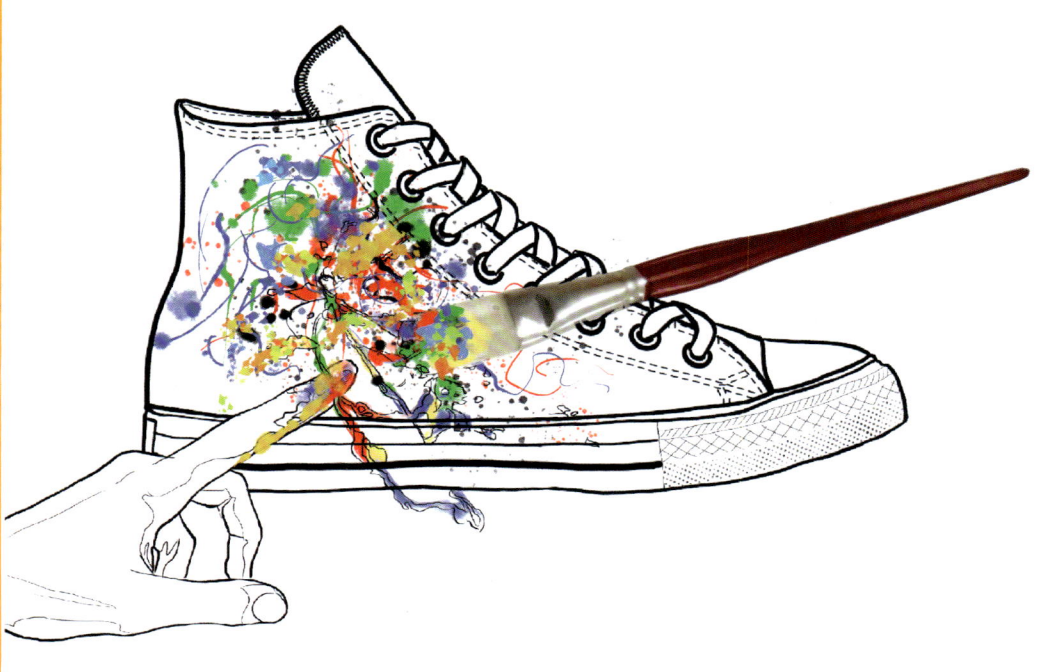

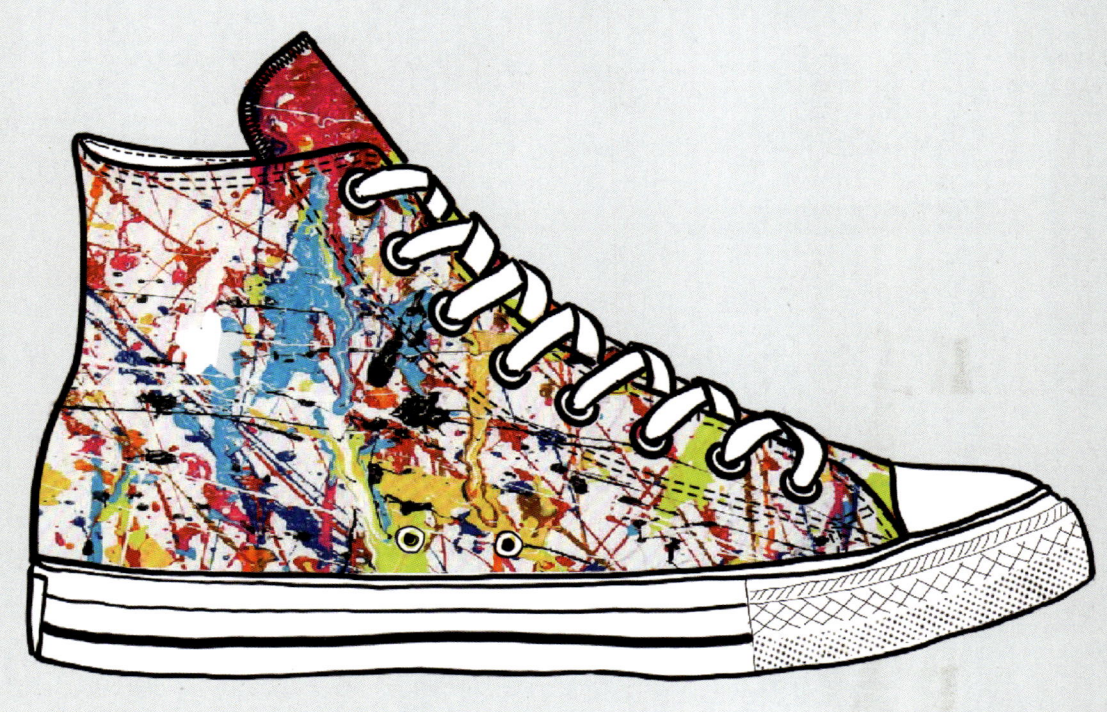

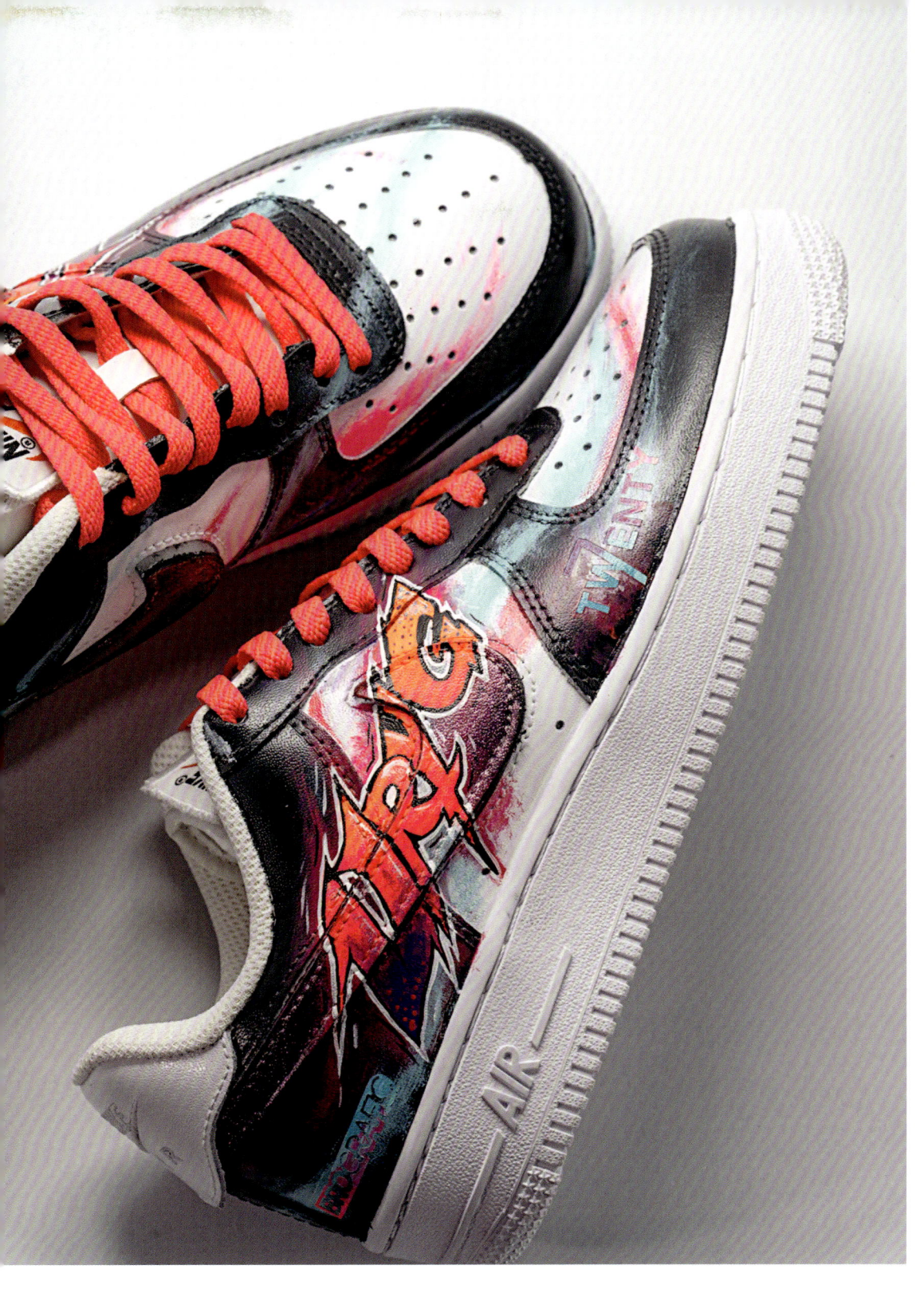

URY, Sergio Domínguez Real, Customs by Sergio (@customsbysergio)

38

40

Wear a Rainbow Louis Vuitton customs, Damikela Gjergji (@dami_customs)

Pop - fluo - metal

44

ISG x CS GF0, Chase Shiel (@chaseshiel)

46

Tutorial 4

Create masks with masking tape to protect the parts of the shoe you do not want to colour.

Airbrush colours.

Use an aerograph to colour the base, using different colours. A simple technique is to use a compressed air can thereby avoiding a bulky compressor.

You can draw the subjects you want with a fine-tipped brush.

Remove the masking tape.

Finish the remaining parts with an acrylic marker. In this case I used a silver-coloured one.

50

Tape, Osipov Alexander Vladimirovich, Can Yaon (@canyaon)

52

54

56

Tutorial 5

With the masking tape mask the parts you do not want to colour.

Completely cover the sole of the shoe as well.

Fill a laundry basin with water. With a spray can spray the paint into the water. Repeat the operation with other colours, always spraying into the centre of the circle formed by the previous colour: rings of various colours will form.

Immerse a stick into the basin and create waves in the paint by moving it from side to side.

Put one or more plastic bags inside the shoe to protect it from the paint and water.

Dip the entire shoe into the basin.

Quickly remove the shoe and let the excess water run off. Colour streaks will stick to the shoe.

Let the colour dry thoroughly, then remove the tape. Finish off the sneaker with one or more paint markers.

Define Chaos, Birch Stanislas, STAN BIRCH
(@staniflou / @floucustoms)

62

64

Camou-flage & animalier

68

Real Tree Camo Dunk Low, John Trottier, Johnnyskicks (@johnnyskicks_)

72

Tutorial 6

Cover the parts you do not wish to colour with tape. Fill the base using a flat brush and acrylic paints.

Proceed by colouring the smaller areas with a thin brush. Once dry cover them with masking tape.

Get some stamps. These simulate a speckled pattern and there are two for each type of stain: one will serve as background to make the print more realistic.

First use a compact stamp of various sizes. Let the paint dry.

Proceed with the second stamp, alternating the different stains.

Finish the job by covering the surface with a finisher.

Magnificient 20D2R, Birch Stanislas, STAN BIRCH
(@staniflou / @floucustoms)

82

Earth Tones, Birch Stanislas, STAN BIRCH
(@staniflou / @floucustoms)

Denim project & Co.

84

86

88

Valte of art work, John Trottier, Johnnyskicks (@johnnyskicks_)

90

92

Fragment Design x Levi's Dunk "FENOM", Bob Ng, no-brainer (@nobrainer.psd)

94

Tutorial 7

Apply masking tape to create a template of the selected area, then cut it out with a utility knife.

Place the template obtained on a piece of felt-type cloth and cut out.

Apply fabric glue to the back of the fabric template. Carefully apply it over the edges with a brush.

Utility knife, scissors, vinyl glue, permanent marker.

Trace parts of the shoe with a permanent marker, in this case faux seams and outlines.

Fire walk with me

Inferno Mocha TS1, Brandon Sanfilippo, Stomping Ground Customs (@stompinggroundcustoms)

100

Shoes on fire, Brandon Sanfilippo, Stomping Ground Customs (@stompinggroundcustoms)

102

Tanjiro AJ1 with Inferno details, Brandon Sanfilippo, Stomping Ground Customs (@stompinggroundcustoms)

104

Bosozoku Dunk, Bob Ng, no-brainer (@nobrainer.psd)

Nightmare

106

108

Venom Carnage, Damikela Gjergji (@dami_customs)

110

Joker Kicks, Brandon Sanfilippo, Stomping Ground Customs (@stompinggroundcustoms)

Killer Whale, warshoe No.3, Edmond Looi Kit Mun, Boomgate art Studio (@edmondlooi)

What the Halloween Dunk, Bob Ng, no-brainer (@nobrainer.psd)

120

122

Tutorial 8

Let's see how to draw on a coloured canvas shoe with bleach. The design will stand out more if done on a dark background. Trace it with a white fabric pencil, or you can use copy paper to trace any design you like and transfer it to the shoe. Fill the shoe with paper to make it easier.

Using a hard brush carefully apply the bleach along the lines of the design. In this way the canvas will whiten.

With a brush splash some diluted acrylic paint.

When using acrylic paints you need to thin them out with a suitable product. Every brand of paint has its own thinner.

Finish the edges and apply wording with acrylic paint markers.

Trace the outlines of the wording with a black permanent marker.

Save the earth

Sahara Oasis, Osipov Alexander Vladimirovich, Can Yaon (@canyaon)

128

130

Camouflage moss, Osipov Alexander Vladimirovich, Can Yaon (@canyaon)

134

XT-6 Moss, Osipov Alexander Vladimirovich, Can Yaon (@canyaon)

136

T-REX custom, Dart Tran, Dart Tran custom (@dart_tran)

Flowers & fruits

Flower Vibe, Osipov Alexander Vladimirovich, Can Yaon (@canyaon)

142

Floral AF1, Damikela Gjergji (@dami_customs)

144

Tutorial 9

Fix the stencil with masking tape. Fill the shoe with paper to keep the stencil taut.

There are stencils of all types with designs or letters. You can create new ones using tracing paper.

Apply the paint with a brush. It should not be too diluted, otherwise it may run. Let it dry well.

Once the paint is dry, remove the stencil.

You can add stickers but they must be highly adhesive. Embossed or glittery ones give a very nice effect. There is something for everyone available to buy.

148

150

New Year Window Flower, Louis Yuang, Yuang Bespoke (@louis_yuang)

152

Tutorial 10

Draw the pattern on the shoe with a pencil. On leather you can use a very thin marker.

Paint with fabric or leather markers.

Finish the outlines with a permanent marker. A dual tip is perfect for creating lines of various thicknesses.

Finally paint the base of the entire shoe, again using markers suitable for leather or fabric.

Staedtler dual tip markers for fabric or lumocolour for leather shoes or polished surfaces.

Pins & patches

158

J4 Vessel, Edmond Looi Kit Mun, Boomgate art Studio (@edmondlooi)

160

162

Beaters, veg tan mid cut vibram sneaker, Edmond Looi Kit Mun,
Boomgate art Studio (@edmondlooi)

164

Tutorial 11

Before starting, use your selected technique to paint the parts of the shoe that you do not want to stay white.

Get an assortment of pins and patches of every shape and colour.

After deciding where to place the patch, apply a touch of vinyl glue to the back of the patch to hold it in place. Stitch the edge with a curved needle or saddler's needle, using thick thread to create a colourful pattern.

Also apply pins to complete the effect. Pins can be changed at any time.

Studs en Converse RUN STAR, María Justina Clementi Villarruel, Justina Aguilera (@justina.aguilera)

Glitter mania

Singapore Sneaker Con 2002R's, Birch Stanislas, STAN BIRCH
(@staniflou / @floucustoms)

170

172

Bucks Crystal AJ1 in Box, John Trottier, Johnnyskicks (@johnnyskicks_)

174

Tutorial 12

With a brush spread vinyl glue over the parts where you want to apply glitter.

Sprinkle a good amount of glitter over the glue-covered surfaces.

Flip the shoe over to remove excess glitter.

With an acrylic paint marker, colour the edges or other parts you wish to highlight.

I love

180

Comme des Garçons customs, Nataša Štuhec, Customs by Nataša (@customsbynatasa)

182

Hearts, Louis Yuang, Yuang Bespoke (@louis_yuang)

184

Custom Air Force 1 "Heartbeat", Nataša Štuhec, Customs by Nataša (@customsbynatasa)

Art gallery

186

Van Gogh, Sergio Domínguez Real, Customs by Sergio (@customsbysergio)

188

192

Van Gogh, Sergio Domínguez Real, Customs by Sergio (@customsbysergio)

Children design

196

198

200

Tutorial 13

Trace childlike designs onto a canvas shoe.

Apply colour loosely with a fabric marker.

To achieve a naive look use the hand you do not normally write with, or use a design actually made by a child.

Use the broadest tipped marker to ouline the design.

The result will be truly unique: the two shoes will be quite different.

Staedtler fabric markers.

204

Mix style

206

"Daniel Arsham" inspired AJ3 customs, John Trottier, Johnnyskicks (@johnnyskicks_)

208

210

Shenron, Dart Tran, Dart Tran custom (@dart_tran)

212

214

216

Vampire Vibes, Osipov Alexander Vladimirovich, Can Yaon
(@canyaon)

218

Tutorial 14

Cover the parts not to be painted with adhesive tape.

Cut out a rectangle of non-compact fabric, such as lace or another perforated fabric.

Hold the rectangle of cloth over the shoe with one hand and spray the paint with the other using a can or an airbrush. Gradually move the fabric around until the entire area is coloured.

You can also use a brush and acrylic paints: in this case it is easier if you fasten the fabric to the shoe with pins. Finally, remove the masking tape. The surface will be painted, while the lace effect will stay the colour of the shoe.

Studs
& Co.

222

Wires, Osipov Alexander Vladimirovich, Can Yaon (@canyaon)

224

Zapas Plateadas, María Justina Clementi Villarruel, Justina Aguilera (@justina.aguilera)

Tutorial 15

Draw spaced out points with a pencil.

Get some studs. These are screw-on and are very easy to apply, but you can also use push-ins.

With a leather punch make holes in the shoe at the pencil points. Fold down the side of the shoe to get to the points at the base.

Insert the inner part of the stud into the holes, then screw on the outer part.

230

Persevera y triunfarás, María Justina Clementi Villarruel, Justina Aguilera for Fito Paez (@justina.aguilera)

232

234

Fondo del mar, María Justina Clementi Villarruel, Justina Aguilera (@justina.aguilera)

236

Tutorial 16

Using a punch, make holes where you want to insert the eyelets.

Insert the eyelet from the inside until the cylindrical part emerges.

There are many types of eyelet in various shapes, colours, and sizes, some of which are quite unusual, like these coloured ones.

Use eyelet pliers to tighten and lock the eyelet. The cylindrical part bends to form the characteristic doughnut shape.

Shadows & stains

240

Vegeta Dunk Low 2.0, Brandon Sanfilippo, Stomping Ground Customs (@stompinggroundcustoms)

242

244

246

Menta Customs, Sergio Domínguez Real, Customs by Sergio (@customsbysergio)

248

250

AF1 Paint Splatter, Nataša Štuhec, Customs by Nataša (@customsbynatasa)

252

254

256

CustomsBySergio X Harper & Neyer collaboration, Sergio Domínguez Real, Customs by Sergio (@customsbysergio)

258

Letter 22

Tupac Custom Kicks, Nataša Štuhec, Customs by Nataša (@customsbynatasa)

Jackboy on the swoosh, Bob Ng, no-brainer (@nobrainer.psd)

Extraordinary women

270

Fur & feathers

272

Green Dragon AJ 1:AF1 with leather carving, Louis Yuang Yuang Bespoke (@louis_yuang)

274

Green Dragon AF1 LUX, John Trottier, Johnnyskicks (@johnnyskicks_)

280

Fuzzy Sambas, Birch Stanislas, STAN BIRCH
(@staniflou / @floucustoms)

282

284

1of1 Editions, Birch Stanislas, STAN BIRCH
(@staniflou / @floucustoms)

Vintage

286

Flow Blue Studio Shot 2, John Trottier, Johnnyskicks (@johnnyskicks_)

288

290

Supreme AJ1, John Trottier, Johnnyskicks (@johnnyskicks_)

292

Marble AF1s, Damikela Gjergji (@dami_customs)

294

Vintage vibes, Dart Tran, Dart Tran custom (@dart_tran)

Simplicity

296

Custom Air Force 1 Draw Pixel, Dart Tran, Dart Tran custom (@dart_tran)

298

Cartoon, Nataša Štuhec, Customs by Nataša (@customsbynatasa)

300

Gradient Cartoon, Damikela Gjergji (@dami_customs)

A pen story

304

308

Tutorial 17

This very simple technique involves using a ballpoint pen of any colour. Create designs directly on the shoe just like scribbling on a piece of paper. You can draw over the entire surface of the shoe or only part of it. If the shoe is made of leather remember to treat it first with a primer.

Black or white

312

Día de los Muertos AJ1 High, John Trottier, Johnnyskicks (@johnnyskicks_)

314

Marble AJ 1 High, John Trottier, Johnnyskicks (@johnnyskicks_)

316

318

Black and white logo pattern, Damikela Gjergji (@dami_customs)

322

Tutorial 18

Always treat leather with a suitable primer before painting the shoes, such as angelus' "preparer and deglazer".

With a broad, flat brush apply lightly thinned paint from the bottom to the top of the shoe.

With a no. 6 pointed brush paint the contrasting parts with visible brush strokes.

To give your shoe a final flourish add coloured or lurex laces.

Acrylic paints, brushes of various sizes.

326

New Stussy nb550 with Stussy logo, Louis Yuang, Yuang Bespoke (@louis_yuang)

PICTURES CREDITS

For all the inspirational illustrations and the tutorials:
© Claudia Ausonia Palazio

Featured Artists

Bob Ng
www.nobrainerkraft.com
Instagram: @nobrainer.psd
P. 93, 105, 119, 267

Brandon Sanfilippo
www.sgny.shop
Instagram: @stompinggroundcustoms
P. 99, 101, 103, 111

Chase Shiel
www.chaseshiel.com
Instagram: @chaseshiel
P. 45

Can Yaon
Instagram: @canyaon
P. 51, 127, 131, 135, 141, 217, 223

Damikela Gjergji
www.damicustoms.com/en
Instagram: @dami_customs
P. 20, 25, 41, 109, 143, 293, 303, 321

Dart Tran
Instagram: @dart_tran
P. 139, 211, 295, 297

Edmond Looi
Instagram: @edmondlooi
P. 115, 159, 163

John Trottier
www.johnnyskicks.mybigcommerce.com
Instagram: @johnnyskicks_
P. 17, 27, 71, 89, 173, 207, 277, 287, 291, 313, 315

Justina Aguilera
Instagram: @justina.aguilera
P. 167, 225, 231, 235

Louis Yuang
www.yuangbespokes.com
Instagram: @louis_yuang
P. 151, 183, 273, 327

Nataša Štuhec
Instagram: @customsbynatasa
P. 181, 185, 251, 265, 299

Sergio Domínguez Real
Instagram: @customsbysergio
P. 37, 187, 195, 247, 257

Stan Birch
Instagram: @staniflou / @floucustoms
P. 61, 79, 83, 169, 281, 285